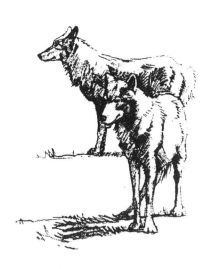

To Wendy Wentworth, editor and friend, whose tireless dedication to this book
never waned and whose love of the wild matches my own. —BD

To my mother who walked with butterflies and taught me to capture wonder
without a net. —EM

A GREENWICH WORKSHOP PRESS BOOK

Copyright ©2001 by The Greenwich Workshop, Inc.
All art ©2001 Bev Doolittle

Published by The Greenwich Workshop, Inc. One Greenwich Place, P.O. Box 875, Shelton, CT 06484
(203) 925-0131 or (800) 243-4246

Library of Congress Cataloging-in-Publication Data
Doolittle, Bev.
Reading the wild / Bev Doolittle [artist]; by Elise Maclay. p. cm.
ISBN 0-86713-061-X (alk. paper)
1. Animals–Juvenile literature. [1. Animals. 2. Wildlife watching.] I. Maclay, Elise. II. Title
QL49 .D64 2001 591–dc21 2001018947

FURTHER READING:

A Beast the Color of Winter, by Douglas H. Chadwick
The Company of Wolves, by Peter Steinhart
Giving Voice to Bear, by David Rockwell
Native American Animal Stories, by Joseph Bruchac
The Natural History of Badgers, by Ernest Neal
North American Mammals, by Roger A. Caras
The Wind Is My Mother, by Bear Heart, with Molly Larkin
Wonders of Coyotes, by Sigmund A. Lavine
The World of the Beaver, by Leonard Lee Rue

Limited edition prints of Bev Doolittle's paintings are available exclusively through The Greenwich Workshop, Inc.
and its 1200 dealers in North America. Collectors interested in obtaining information on available releases
and the location of their nearest dealer are requested to visit our website at www.greenwichworkshop.com
or to write or call the publisher at the address above.

BEV DOOLITTLE'S WATERCOLOR PAINTINGS IN THIS BOOK:

Badger, p.11; *Beauty and the Beast*, p.25; *Broken Silence*, p.15; *Christmas Day, Give or Take a Week*, detail, p.32;
High Life, p.19; *Missed!*, p.30; *101° in the Shade*, p.26; *Small World*, pp.4-5; *Snowshoe Tracks*, p.8;
Spirit Takes Flight, The, p.23; *Spot of Sunshine, A*, pp.16-17; *Walk Softly*, p.28; *Whoo!?*, p.13;
Wilderness! Wilderness?, detail, p.20; *Winterwolf*, p.29; *Wolftrack*, detail, title page; p.24; *Yesterday's Nectar*, p.7

Jacket front: *Walk Softly* Jacket back: *Real Bear*

Book design by Marc Zaref Design, Inc. Norwalk, CT
Manufactured in Japan by Toppan
First Printing 2001

1 2 3 4 5 04 03 02 01

Bev Doolittle

Reading the Wild

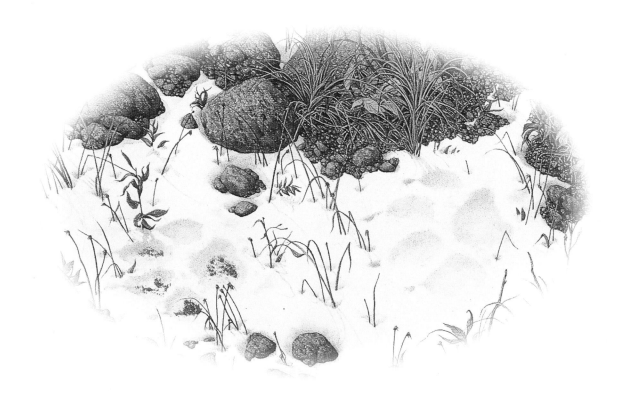

by Elise Maclay

THE GREENWICH WORKSHOP PRESS

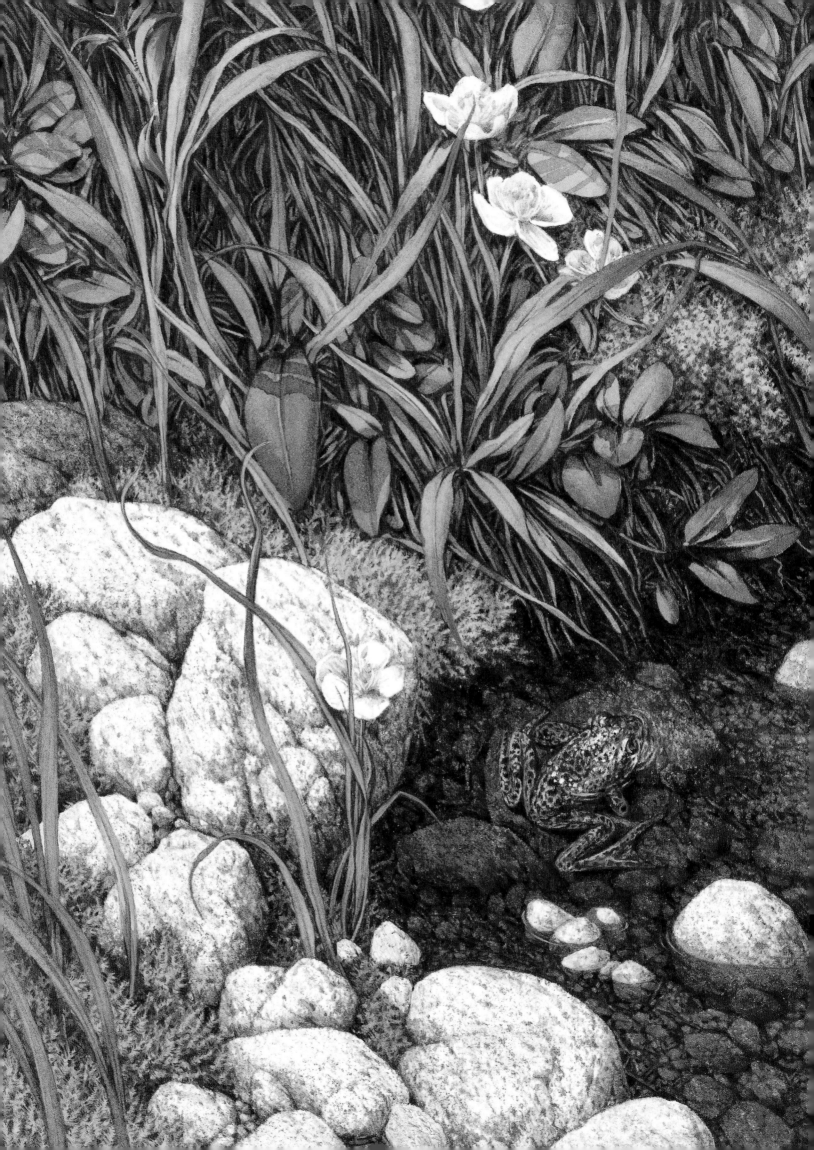

How to Read the Wild

Did you ever go on a hike and feel disappointed because you didn't see a grizzly bear, or a trumpeting moose, or a beaver? There is "wild" life all around us, in city parks, seashores, and backyards. Even a desert is teeming with fascinating creatures and clues to nature's mysteries. Here are a few ideas that can make your next wildlife walk more exciting.

1. Walk early in the day or the evening. Birds and animals are most active during the early morning and at dusk.

2. Be quiet. Wild creatures hear every sound and are aware of every movement. Talking, shouting, and chasing butterflies send a message far and wide: Go! Hide!

3. Go in a small group, or split up and walk in groups of two or three.

4. Hike with a purpose or destination. Find signs of spring. Follow a brook to a waterfall. Walk a high ridge in hope of seeing hawks and eagles riding the wind. Revisit an osprey nest to see if the eggs have hatched. Look for frogs and toads.

5. Bring a field guide. With a field guide, you might identify what at first looks like a stone, as a yellow-legged mountain frog found in the Sierra Nevada mountains at six thousand feet, sometimes as high as ten thousand feet, above sea level.

6. Bring binoculars for seeing birds and for searching distant meadows for deer. And bring a small magnifying glass for examining insects, flowers, moss, and tree bark.

Hummingbird

Would you like to see a bird change color before your eyes, from emerald green to black or from red to purple to gray? Would you like to see it fly backwards? Fly ninety miles an hour and brake to a complete stop in midair? Fly upside down? Watch a hummingbird!

The smallest birds in the world do all of these tricks with such grace and ease, they make it look like magic. Ancient people thought it *was* magic. Mayan Indians said that hummingbirds received the ability to change color from the Sun God—but only when the birds looked at him face-to-face. If they turned away from the light, their feathers would turn dark again.

The hummingbird's color *does* depend upon the light and the angle from which you view it. This kind of changeability is called *iridescence,* and it has fascinated scientists for hundreds of years. Isaac Newton, the English physicist, mathematician, and astronomer, was one of the first scientists to focus on hummingbirds and light. He had the idea that some of the particles that make up a hummingbird's feathers are clear and colorless, but reflect color (the way a soap bubble does) in direct sunlight. He was on the right track, and, with the advent of high-powered microscopes, scientists have been able to analyze and explain iridescence in great detail.

One day, you may get to examine a hummingbird feather under a microscope. In the meantime, if you find a hummingbird feather, you can test its changeability by placing it in a sunny spot and moving about to view it from different angles. To get the best view of a hummingbird in the field, stand with the sun behind you.

The hummingbird's flying ability has also been the subject of much scientific study. Thousands of measurements and photographs have been taken of the figure-eight pattern of the wing beat, of the slant of the wing tips when the bird is hovering, and of the skeletal structure of the wings. Aeronautical engineers would love to be able to make a flying machine that could shoot straight up, fly ninety miles an hour and then screech to a full stop in midair, take a nosedive and land without cracking a bird's egg. Hummingbirds do it every day.

Hummingbirds need a lot of food—insects and the nectar of flowers—to fuel their activity. In fact, they need to fill up every ten minutes! This is good news if you're interested in hummingbird watching. If you see hummingbirds in a field of flowers, chances are they will soon be back again and again, for they are definitely creatures of habit.

If you want to invite them to your place, hang a syrup feeder near a window. You can buy a feeder at a supermarket or hardware store or you could make one by punching a hole in the cap of a small plastic bottle. Wrap a wire around the bottle to hang it from a tree branch or a clothesline. Fill the feeder or bottle with a mixture of sugar and water. If you are putting out a feeder for

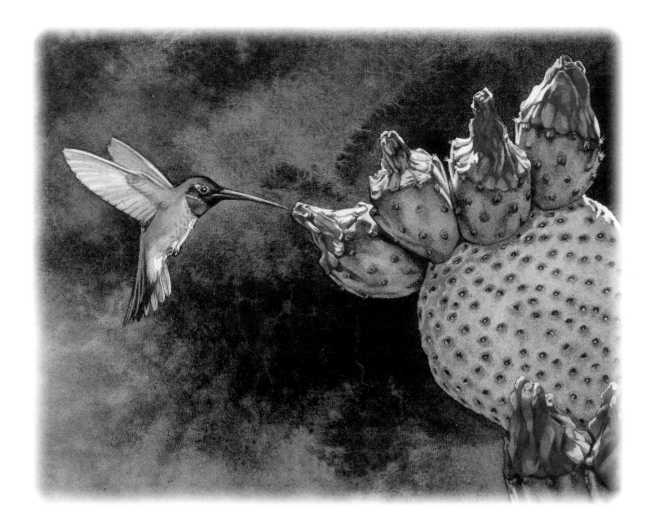

the first time, use one with a red cap or nozzle. Hummingbirds are attracted to the color red—probably because red flowers have the nectar they consider most delicious. After a while, if they like your sugar-water, they'll come back for more no matter what color the container is. Another way to welcome hummingbirds to your garden is to plant their favorite flowers: honeysuckle, yucca, phlox, azalea, rose of Sharon, delphinium, columbine, trumpet vine, and petunia.

In the field or in your garden, hummingbirds are a delight to watch. They are fierce little fighters that build intricate nests and catch flies with great skill. They can take a shower in the dew collected on leaves. They notice every change in their environment. And always and above all, they perform amazing aerial acrobatics and light up the sky with their brilliance. No wonder the ancient Aztecs believed that when a hero died in battle, he became a hummingbird, "the shining one, bird, warrior, wizard with the magic to bring back the sun."

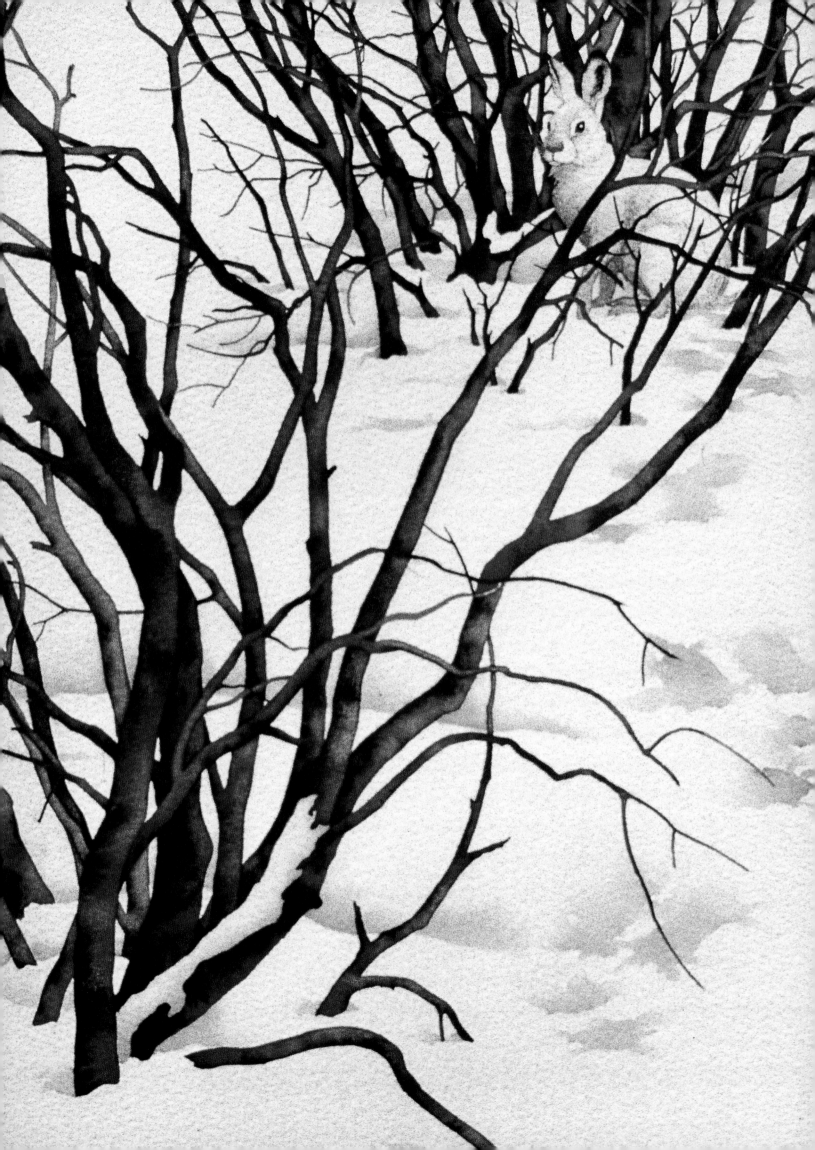

Snowshoe Hare

The snowshoe hare *(Lepus americanus)*, also called *varying hare,* has a secret weapon. It is dark brown in summer but, as winter approaches, it begins to grow a white-tipped coat that is splotchy at first, to match a landscape with patches of snow. By the time deep snow covers the ground, the hare, too, is snow-white and almost invisible. In a snowy field, this coloring protects him as he hops quickly toward home. But will the hare's tracks lead enemies to his hideaway? Probably not. The wind has already begun to push snow into his telltale tracks, and soon the drifting snow will erase them completely.

Every track is a mystery story. If you can identify the creature that made the track, you're on page one because you know who the main character is. Deer. Coyote. Fox. To find out what happens next, follow the tracks! But don't go too fast. Deer tracks are not just deer tracks. They are the tracks of one particular deer. Expert trackers can tell whether that deer is young or old, strong or feeble, tired, hungry, or feeling frisky.

It takes years to learn to track like that. But you can solve many mysteries by careful observation and by asking yourself a few questions. Why do squirrel tracks lead off the trail and back again? Follow the tracks. Maybe they lead to an oak tree with acorns beneath it. The mystery is solved: the squirrel went for a snack. Why do the fox tracks start and stop? The fox hears something that worries him. He stops. He listens. He sniffs the air. Then he goes nervously on. Why do the coyote's tracks keep going in circles? Maybe you're on an old logging road with bits and pieces of machinery lying on the ground. Coyotes are curious about everything. This coyote has circled each piece of rusting machinery, again and again, closer and closer. Is it something to eat? Something to play with?

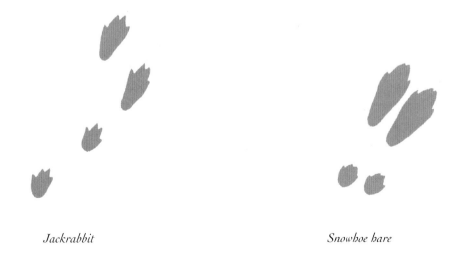

Jackrabbit *Snowshoe hare*

Badger

Some animals have all the luck—if you call it lucky to be famous. The badger became a celebrity fifty years ago when a remote-controlled infrared camera caught him cavorting around in the dark, and an English schoolteacher (whose hobby was watching badgers) showed the film on television. Suddenly, people all over England were holding badger-watching parties.

Why were so many people bitten by the badger-watching bug? For one thing, badgers are very cute. The young romp and roughhouse. The parents (the *boar* and the *sow*) do housekeeping chores like cleaning out old bedding and replacing it with new. Badgers are common in England and in the United States, but few people ever see one because almost everything badgers do, except sleep, they do at night. They are nocturnal animals.

To watch badgers, you have to go out at night. If you can, go by the light of a full moon. You'll need to be very quiet, so wear sneakers and choose a flashlight with a silent switch. Experts like to use a light with a red filter because badgers take little notice of the color red. But sometimes these unpredictable little creatures go about their business boldly in the beam of an ordinary flashlight.

The biggest challenge of badger-watching is choosing which hole to watch. A badger's home (called a *sett*) can have as many as fifty entrances. When you have decided which one to watch, you'll need to get there by sunset at the latest. As the badgers emerge, they will probably be cautious—so you should be very quiet. When the badgers decide the coast is clear, they will scamper off and bustle about looking for food—beetles, earthworms, lizards, mice, acorns, and seeds. Once they have eaten, and if they feel they are safe, they may chase each other, tear up bushes, and slide down slopes. A badger never has a dull night!

The European badger *(Meles meles)* and the American badger *(Taxidea taxus)* belong to the weasel family (Mustelidae). With small heads, wedge-shaped bodies, powerful legs, and feet equipped with strong claws, they are perfectly designed for digging. They dig bedrooms, rooms for mating, and nursery rooms where the little cubs can play. They make tunnels for storing food, for going from place to place, and for draining off rainwater. Even when they have created a sett large enough for their every need, badgers seem to enjoy adding rooms to their underground mansions. You may know people like that!

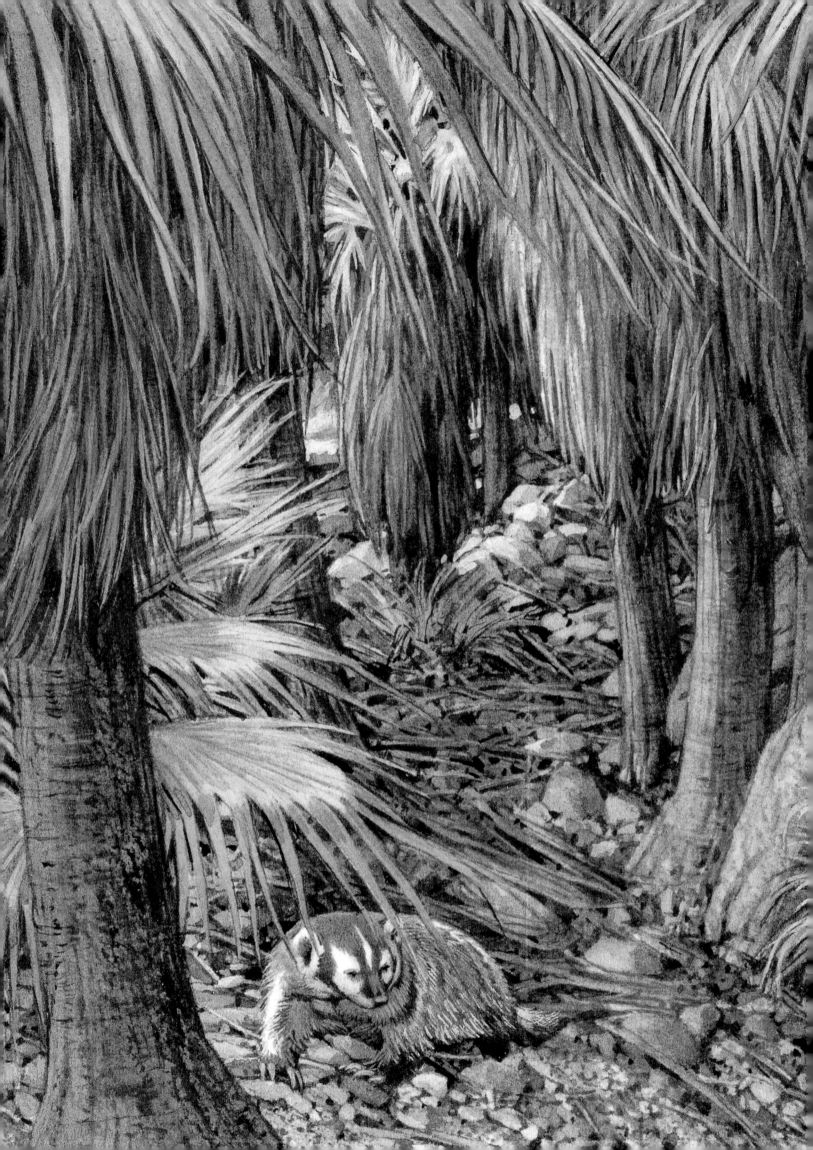

Beaver

Big things attract attention, but small things often have the power to bring about big changes. A forest is turned into a swamp and a stream is turned into a lake because a dam has been built by small, humpbacked, fur-covered creatures with tails shaped like canoe paddles. Eager beavers? You bet. And the word eager doesn't begin to describe the beaver's idea of a day's work. A single beaver can cut down a five-inch-diameter willow tree in three minutes, a six-inch-diameter birch tree in ten minutes, and, even if it takes him all day, he will cheerfully chomp down a tree as thick as thirty inches in diameter. Working feverishly (and beavers always work feverishly), a pair of beavers can build a strong dam in three nights. Long dams take longer to build, and beaver dams as long as four thousand feet have been reported.

Once the beavers have built a dam across a stream, and that dam has created a lake, the beavers get to work again. Each beaver family builds a house *(lodge)* in the lake. Why not in a nice dry field nearby? Because a beaver's home is designed to keep the family safe as well as comfortable, and beavers feel safest in, or under, the water. They're superb swimmers. They breathe air, but their lungs are specially constructed to enable them to swim underwater for half a mile or more. A house completely surrounded by water is the safest house in the world for them. They build their lodges out of twigs, branches, and sticks plastered with mud.

Every lodge has a secret underwater entrance. Other animals, even good swimmers, cannot find it. How do the *beavers* find it? They put on their swimming goggles. Actually, they wear them all the time. Beavers have transparent eyelids that protect their eyes from irritation when they dive and give them perfect vision underwater.

Beavers are very private and shy, but *signs* of beavers are easy to spot: cone-shaped tree trunks with teeth marks all around, and dams and lodges built out of branches and twigs. Even when snow falls on the roof of their lodge, and the lake is a sheet of ice, many beaver families may live in the dry rooms above the water level. Their fur coats and body fat protect them from the cold. Holes with underground entrances hold food that they have gathered and stored. If the mud roof and sides of the lodge freeze solid, the beaver are even safer because bears, foxes, and wolves cannot break in.

During the winter, the hardworking beaver gets his reward. While other animals brave storms to hunt for shelter and food, the beaver will cuddle up with his mate and young ones, cozy and warm, in a home of his own making.

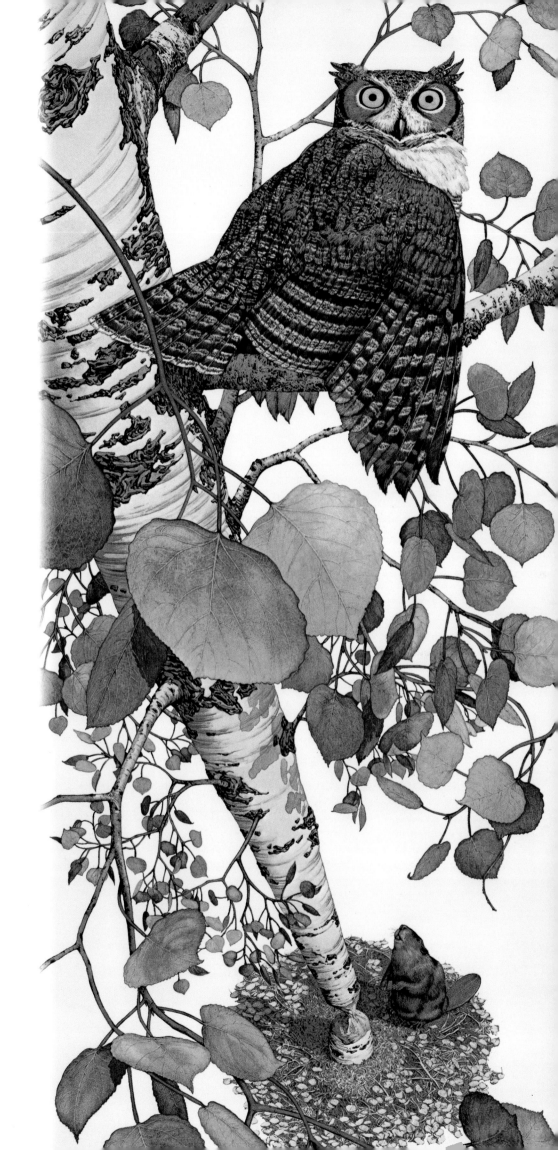

A beach is made of grains of sand.

Tiny seeds transform the land

into a forest or grassy hill.

Drop by drop the oceans fill.

Bite by bite a mighty tree will fall.

It all begins with something small.

Deer

When you squat down to study an animal's tracks, you have the opportunity to enter that animal's world. For a few moments, you can almost *become* the animal. You breathe in the piney smell of the forest. You enjoy its coolness. When you put out a hand to steady yourself, you feel the prickle of dry pine needles under your palm. Because you are being very quiet, you hear sounds you did not notice before: the rustling of leaves, the *tsik, tsik, tsik* of the chickaree or pine squirrel.

You are only faintly aware of the sounds because you are focusing all of your attention on the tracks as they move from under the cover of the pine trees and into the snow. The tracks tell you that they were made by an *ungulate*, a hoofed animal belonging to a group that includes the elephant. (Forget the elephant.) *These* prints are small and neat and heart-shaped. Clearly they were made by some member of the deer family. Exactly which member is harder to say. The tracks are too small for a moose or an elk. A deer then, but which deer? If you find that question hard to answer, you're not alone.

Olaus Murie, a leading mammalogist, says, "I must confess that I have found no way to distinguish the footprints of our three kinds of deer." He suggests turning to geography for an answer. If you're in the East, you're probably looking at the tracks of a whitetail deer. In the West, it's probably a mule deer, although whitetail deer have been seen as far west as Utah and Arizona.

At full size, healthy deer are able to outrun most of their enemies. At a full run, mule deer hit the ground with all four hooves at once. This is called *stotting* and it leaves a distinctive print. At a walk, mule deer make tracks that resemble those of other deer, in a staggered pattern of heart-shaped prints. Measuring the distance between prints will tell you the length of the animal's stride. This information can help you identify which member of the deer family made the tracks. Whitetail deer have the shortest stride, around one foot long. The mule deer's stride can be twice as long, and the elk's stride is the longest (because elks are taller, with longer legs) and can be up to five feet long.

As the name suggests, whitetail deer have tails, which are brown on top and white underneath. When they run the white part of the tail flips up like a little flag. Whitetail deer are found in most of the United States, except the Southwest. The mule deer's tail is white on top and tipped with black. It's found in the Yukon and central United States.

The mule deer has glands located above the hooves of its hind legs. A fawn is able to recognize its mother by the odor from these glands. Perhaps there is an Indian legend about that. Indian legends are more than just fanciful stories. They are full of forest truths.

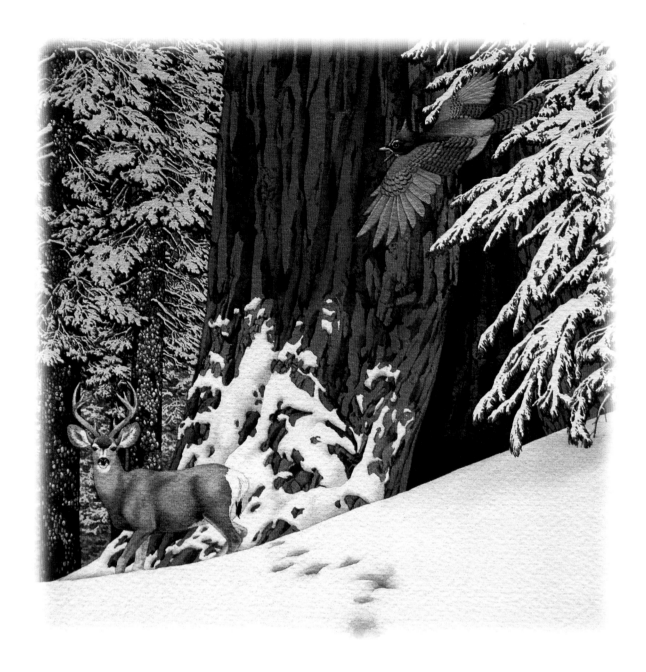

How the Deer Got Its Spots

In the beginning:

The Great Spirit made the earth.

Then he made the animals.

The animals were all different, big and small,

Fierce and mild. He loved them all.

So he gave them gifts to help them survive.

He gave the bear sharp teeth and claws.

He gave the wolf silent paws.

He gave the deer superior speed.

He gave tortoise a shell. He gave porcupine quills.

Then he went to rest beyond the hills.

But a mother led her wobbly-legged fawn

Into the presence of He-who-made-dawn.

"Oh Wise One," she said, "You have given all of the animals

Wonderful gifts to help them survive:

But what will become of my wobbly-legged child?

She cannot yet run fast like me.

Our enemies will catch her easily."

So with some paint made from the earth,

The Great Spirit painted earth-colored spots on the tiny deer.

"You will be invisible," he told the fawn.

"Stand still as a stone until your enemy is gone."

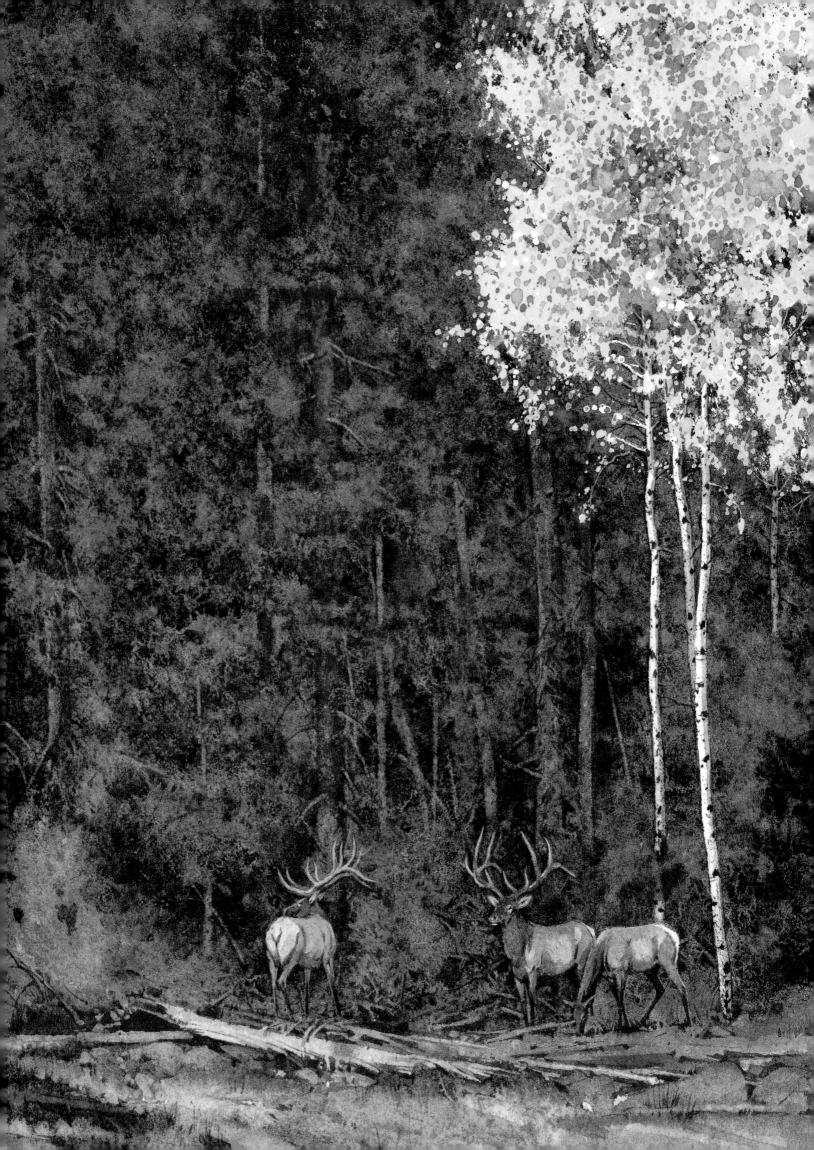

Capturing the Wild

Hopefully, you will never be forced to shoot a wild animal and eat it in order to survive. Today, many people still hunt animals for sport, and much of the fun of that sport is simply being outdoors and being part of the great, vast forest. It is thrilling to rise before dawn, walk through a dark forest at first light, search for tracks and signs, crouch in a sweet fern-smelling place, waiting, watching, alert to every sight and sound.

If you carry a camera instead of a gun, you might bring home a double reward: photographs of animals and the joy of knowing that wild creatures are there. You don't need to be a famous nature photographer to take pictures that capture wonderful moments you have spent in the wilderness. And you don't need a fancy camera. In fact, a special camera may require extra equipment that you're not likely to grab each time you take a walk in the woods. A small, lightweight, easy-to-operate camera is what you need for capturing unexpected moments . . . a shaft of sunlight turning a tree gold, a chipmunk poking its head out of a fallen log, or elks pausing at the edge of a meadow.

Use of a camera teaches you to see things in a different way. You look up from the trail, notice the sky, observe the way shadows fall on grass, and just generally pay more attention to color. You will need to practice until you can operate your camera easily, but you don't need to study photography to take the kind of picture we are talking about (although you may want to). Photographs can bring back many memories of a wilderness walk. If you're quiet, observant, and lucky, you'll even have photographs of animals.

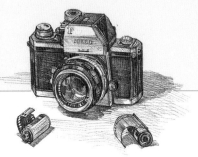

Mountain Goat

If you try reading the wild with binoculars, you're in for a lot of fun. Focus on a mountain: rocks and snow. But wait a minute—is that patch of snow moving? Definitely. Melting? Not likely, because it's moving up. Adjust the focus to get a closer look. Mountain goats! Six of them—no, seven. Eight? Snow-white with black horns and twinkling black hooves, the goats leap from rock to rock. One balances on a pointy peak. Now they're all walking along a ledge that looks to be about two inches wide with a thousand-foot drop on either side. This is like watching the high-wire act at the circus, only these performers wear shaggy fur coats and strut their stuff in high winds and snowstorms—and they bring their kids along. "Look, Ma, no safety net." Goat babies are called *kids* but the mountain climbing they do is not kid's stuff.

Without a doubt, mountain goats are world-class mountain climbers. More surefooted than any other native animal, they can climb fast and high, twenty miles per hour up a rock face with no visible footholds. "We're kings of the mountain," they seem to say. "Catch us if you can." Few predators dare to try, except one: a human with a gun.

If you look for mountain goats in an area where hunting is permitted, you may have a hard time seeing any. Mountain goats may be there, but they have phenomenal eyesight and they seem to know, even from far away, when hunters are about. If they see even one human in the distance, the whole group will bolt before you can get your binoculars up to your eyes. Your chances of seeing mountain goats are better in protected areas such as Glacier National Park or Banff National Park. Goats in these areas are accustomed to backpackers hiking through their territory. Standing quietly with a pair of binoculars, you might get a good look at them.

Mountain goats eat grass, twigs, flowers, and herbs. You may see them challenge each other with a nudge of the shoulder—body language for "You're eating from my plate, brother. Buzz off." You will surely be able to distinguish the big, male billy goats from the tiny kids. Although it is possible to tell a mountain goat's age by its size, even experts have a hard time doing it from a distance.

Adult males *(billies)* are the largest and weigh between 150 and 225 pounds. The weight of adult females *(nannies)* averages around 140 pounds. *Yearlings* (one-year-olds) weigh between 45 and 70 pounds. Kids (newborn to 11 months of age) can start as small as seven pounds.

Kids stay close to their mothers. Within a herd, little groups of nannies and youngsters like to pal around together. If you're lucky enough to see them in the wild, what will strike you most about these splendid white climbers is how joyously at home they are in a barren world where the air is thin and pure and the sky is the only roof they have ever known.

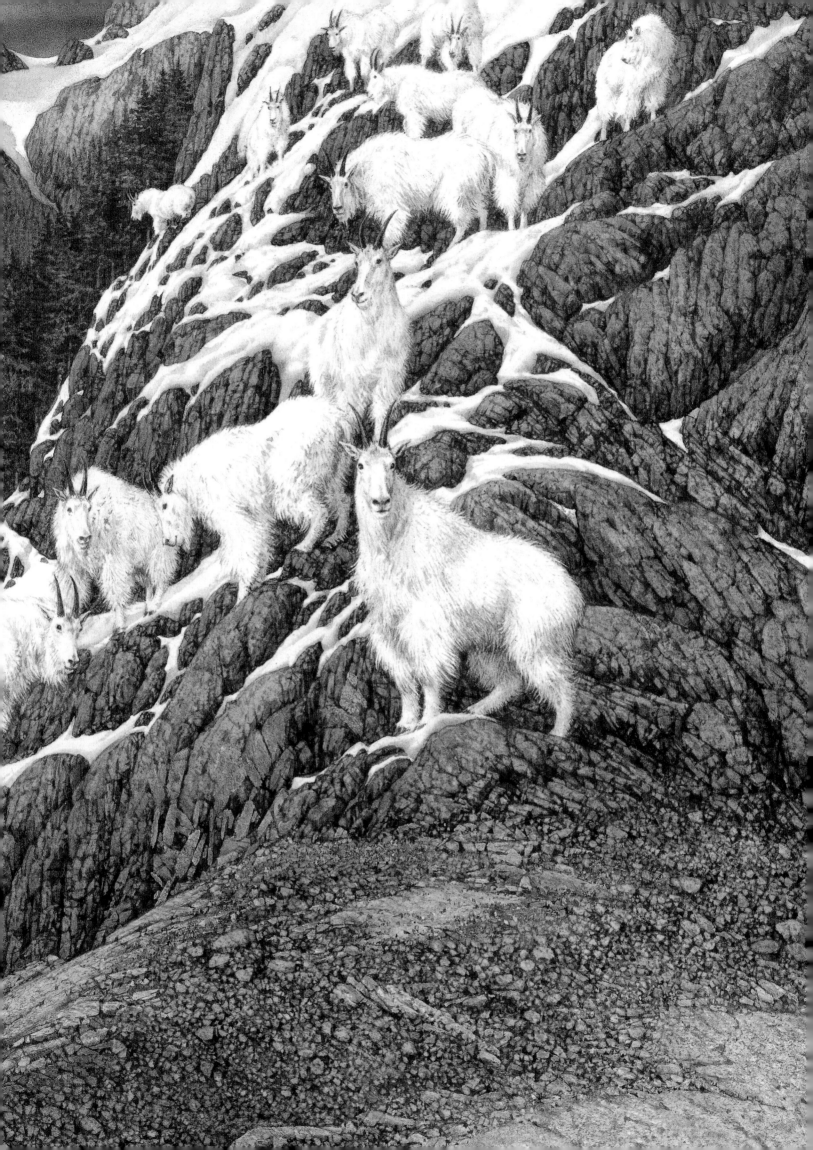

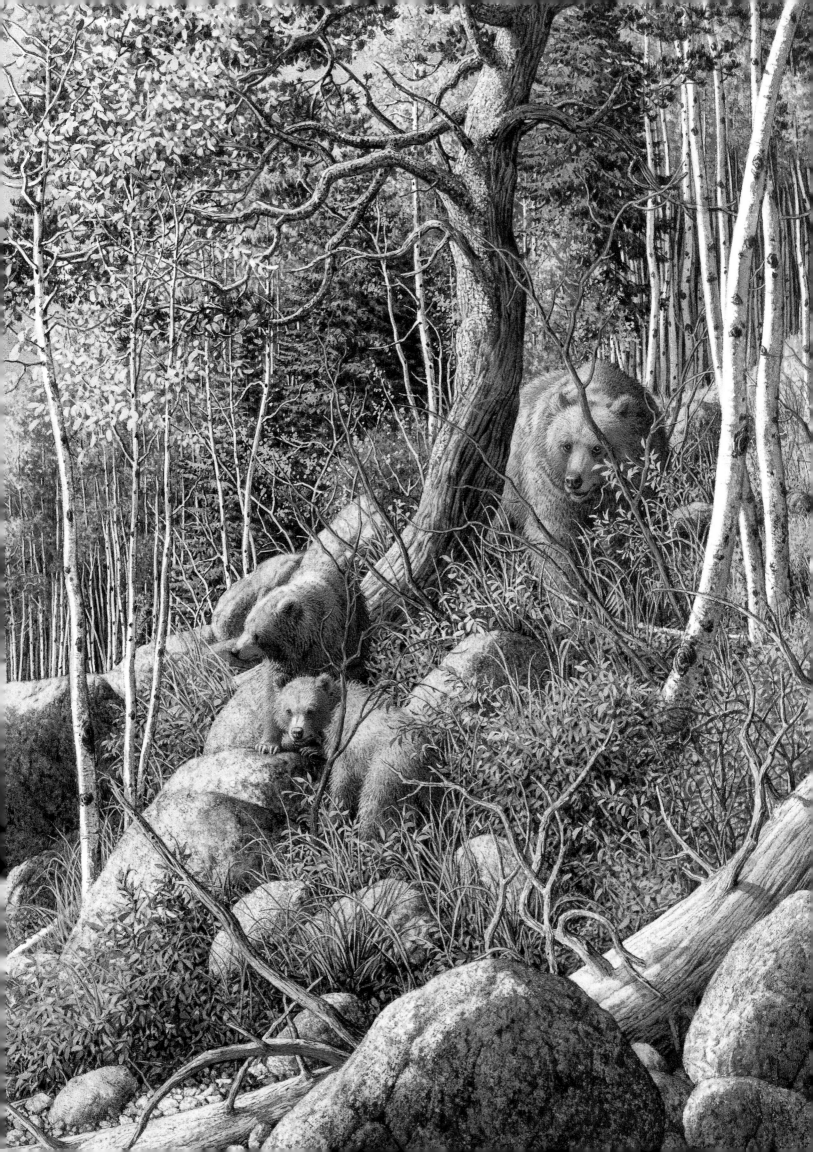

Bear

Native Americans knew a great deal about bears. Many tribes associated bears with healing. Perhaps this was because bears ate the roots and leaves of the plants Indians used for soothing aches and pains, and for helping wounds heal. The Lakota called these healing herbs *bear medicine*. In the language of the Zuni Pueblo, the word for doctor is the same as the word for bear. Whenever a Zuni Pueblo doctor went to help a sick person, he wore a string of bear claws around his neck. He would ask the spirit of the bear for help in curing illness and healing wounds. The Blackfeet Indians' name for the grizzly bear translates to *real bear*, which grizzlies certainly are.

Bears *do* look and act like people, more than most large animals. They can stand on their hind legs and walk upright. When they sit, they hold their front legs up like arms. Bears are omnivores, so they eat what people eat—not just grass or only meat but vegetables and fruit, nuts, salad greens, mushrooms, and berries. They even go fishing!

In June, when the salmon swim upstream to spawn, bears gather on the banks of rivers and streams to look for dinner. They trot up and down the shore leaving a well-worn trail. When it's time to rest, they make sleeping places beneath willows and alders. Olaus Murie, a leading mammalogist, once found beds that the bears had carefully prepared by scraping together piles of moss twelve feet in diameter—super-comfortable mattresses for extra-fussy bears.

Grizzly bears used to be common throughout the western United States, but now they are endangered in all regions except Alaska and western Canada. Bears need large areas, up to one thousand square miles, to roam for food. Their tracks are easy to identify—roughly human in shape, but much larger and wider, with marks at the ends of the toes made by their claws. The black bear is the smallest American bear and the grizzly is the largest. *His* tracks are enormous.

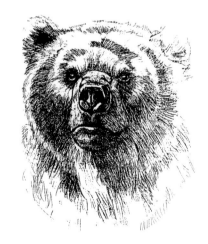

In the wild, bears tend to avoid human contact, but if you are in bear country, don't count on their shyness. Bears can be dangerous, especially females with their cubs. And don't plan to run away and climb a tree for safety. A black bear can run twenty-five miles an hour and climb a tree faster than you can say *o-kits-iks*, which happens to be the Blackfeet word for bear's claw.

Butterfly

When the Great Creator finished making the mammals, birds, reptiles, amphibians and fish, he had many baskets of bits and pieces left over. There were scraps of all the colors in the rainbow—ribbons of red, bands of blue, yards of yellow, orange, green, violet, and all the colors in between, like magenta, teal, and aquamarine. So the Creator, who never wasted anything, turned the leftover scraps into butterflies.

Even the Great Creator was astonished at the beautiful butterflies that fluttered and danced in the new blue sky. He had intended to give them pretty singing voices, too, but he was afraid that some of the little brown songbirds might become jealous. He wanted all of Earth's creatures to be happy. Today butterflies fill the sky with color and songbirds fill the air with music.

This is a story from the Papago Indians, who roamed the deserts of the American Southwest for many years. Today these "People of the Desert" live mostly on reservations located in Pima County, Arizona. They still tell beautiful stories.

You probably know a lot of bird-watchers and not very many butterfly-watchers, but that may be changing. Not too long ago, students were encouraged to study butterflies by capturing them, killing them, and mounting them on boards for identification. Today many naturalists prefer to observe butterflies in their natural habitats. In this way, they can learn not only what butterflies look like, but what, when, where, and sometimes why they do the things they do. There is a lot to learn, too, because butterflies lead amazing lives. There are seven hundred species in North America alone, and the behavior of some species is still unknown.

There is more to a butterfly than meets the eye. Butterflies start life as caterpillars. The life cycle from tiny egg, to wiggly caterpillar, to motionless cocoon *(chrysalis)*, to an exquisitely winged creature that looks like a flower dancing in the wind, is called *complete metamorphosis*.

You only need two things to begin your study of butterflies: a field guide and a notebook. Both should be small enough to fit in your pocket. Bird-watchers insist on binoculars but butterflies are easier to watch with the naked eye. A butterfly may flit away when you approach, but it will usually alight again nearby. Sooner or later, if you are patient and stealthy, you will be able to look at it long enough to find its picture in your field guide. Record the identification in your notebook. Also record the time of year, the time of day, the location, and the plants and flowers that seem to be attracting the butterfly. If you don't recognize these plants and flowers, describe them and make a sketch so that you can identify them in a botanical guide when you get home.

It is important to include habitat information. Although butterflies are fragile and have many predators, they have survived for millions of years. The one thing they cannot survive is loss of their habitat, and today that is happening everywhere. In 1942, a lovely lilac-blue butterfly disappeared forever because the military developed land in San Francisco, California, where the last colony on Earth lived. An international organization was created to protect unique butterfly habitats, and it is named for Xerces Blue, the butterfly that became extinct in San Francisco.

Because there are so many species of butterflies (at least ten thousand worldwide) and there are so many ways to enjoy them—reading, field observation, taking classes, joining a butterfly club (or founding your own), even raising them—butterflies are endlessly fascinating. Even their names sound like characters in science fiction or fantasy stories: *Great Purple Hairstreak, Cloudless Giant Sulphur, Apache Skipper, Tiger Swallowtail, Frosted Elfin, Sleepy Orange, Zela Metalmark.*

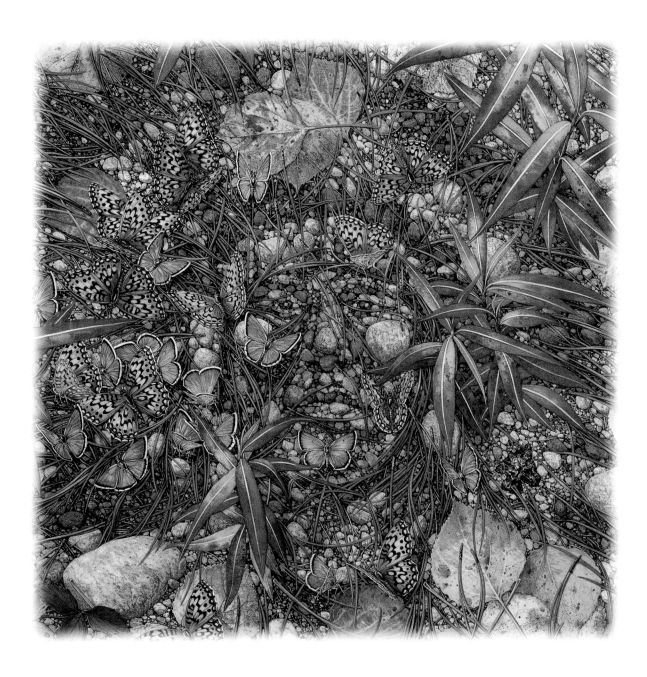

Observing the Wild

The ability to glide silently over the earth is your ticket to observing wildlife. With some practice, you could see a mother bird feeding her young, a fawn drinking from a forest stream at dawn, a monarch butterfly sipping nectar from a flower, a heron diving for fish, or a motionless but totally alert fox.

Native American children learned how to track small animals as soon as they could walk. By the time they were ten, they could hunt jackrabbits with throwing sticks—not for fun, but to provide food for the family. Today, since we buy food at the supermarket, our senses have become dull from disuse. When we venture into the woods, we miss many of its thrilling secrets.

With practice, you can learn to walk softly in tune with the wilderness. There are just two skills you need. First, notice and understand every motion, every sound, every bit of evidence that suggests a wild creature is, or was, nearby. Second, move about without making your own presence known.

You can begin in your backyard or in any other small, natural area. Walk through it until it is thoroughly familiar. Next, walk through it barefoot. Notice how much more carefully you put each foot down, testing the ground before putting your full weight on it. Suddenly, you care about what is underfoot. Ouch! Sharp gravel. Ooh, soft grass.

Now, still barefoot, walk the same patch of land blindfolded. Without sight, you are totally dependent on your feet to feel your way. Your feet let you know that you are crossing the gravel path, or the lawn, or the flowerbed. Tomorrow, do the exercise again. Soon you will know this piece of earth as well as you know your own face or hand. You will be aware that there are many ways of walking.

Another fun way to practice walking softly is to play a game called "Hunter." One player is the animal that stands near a tree, facing it. The other players

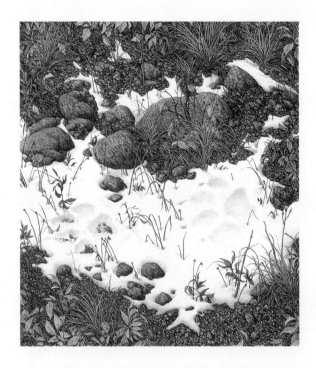

pretend to be hunters as they sneak through the woods trying to be the first one to tag the "animal" without being heard.

You need to be able to stop completely still at a moment's notice when tracking and observing wildlife. You practice this skill when you play "Statues." The leader shouts, "Freeze!" and everyone must stop instantly, holding their exact position.

Of course if you want to stalk a particular animal, you will need to know where to look for it. The wolverine, for example, is found in the tundra (plains and mountains of the far north) but not in New York City's Central Park. Foxes and rodents can be found nearly everywhere: in the arctic wastes, in the temperate zones, on the plains, and in the mountains. Deer, coyote, and hare are also common. If you live near a pond, lake, or river (or the ocean), you can find tracks near the edge of the water where many forms of wildlife live or come to find food.

Tortoise

The tortoise lives in the world's oldest mobile home. What it lacks in the way of bumper stickers and rearview mirrors, it makes up for with convenience features. It requires no furniture, the roof never leaks, and the owner never needs to worry about losing the door key.

But are tortoises the same as turtles? Actually, yes, and they date back to the dinosaur age. There are sea turtles, freshwater turtles, and land turtles. They're all reptiles and they all belong to a reptilian order called *chelonia*. In England, and sometimes in North America, land turtles are called tortoises. No matter what you call it, a tortoise or land turtle, its track is worth hunting for. Follow it and you might catch up with a tortoise.

A tortoise track is fairly easy to identify if you know a little about tortoises. Tortoises have a head, a tail, and two shells: a top shell *(carapace)* and a bottom shell *(plastron)*. They have four limbs that are club-shaped. Each club ends in four or five claws. The track depends on the shape of the plastron, how high the turtle is carrying it, and also whether the ground is hard or soft. If a short-legged turtle is dragging most of its bottom shell across soft mud, the track will be a broad band that may wipe out many or all of the turtle's claw prints. A long-legged turtle walking on firm ground will leave a double row of footprints and claws, and a narrow line running between them made by the turtle's dragging tail.

Although there are more than two hundred species of turtles in the world (and they are found all over the world), many species are strictly regional. For example, there are only two species of land turtle in southern California: the western pond turtle and the desert tortoise. The alligator snapper, a large, bad-tempered turtle with powerful jaws, is mostly confined to the Mississippi and Missouri river basins of the eastern United States.

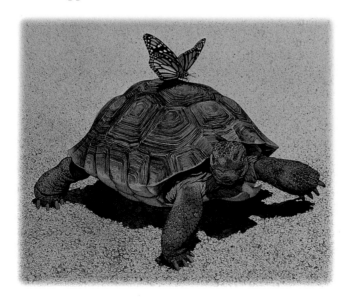

While strong shells and snapping beaks protect turtles from most predators, they are no match for human beings who decided that turtle meat was tasty, and turtle shells made beautiful jewelry and combs. But, if we choose to help them, turtles and tortoises may live happily ever after in their attached, non-gas-guzzling mobile homes.

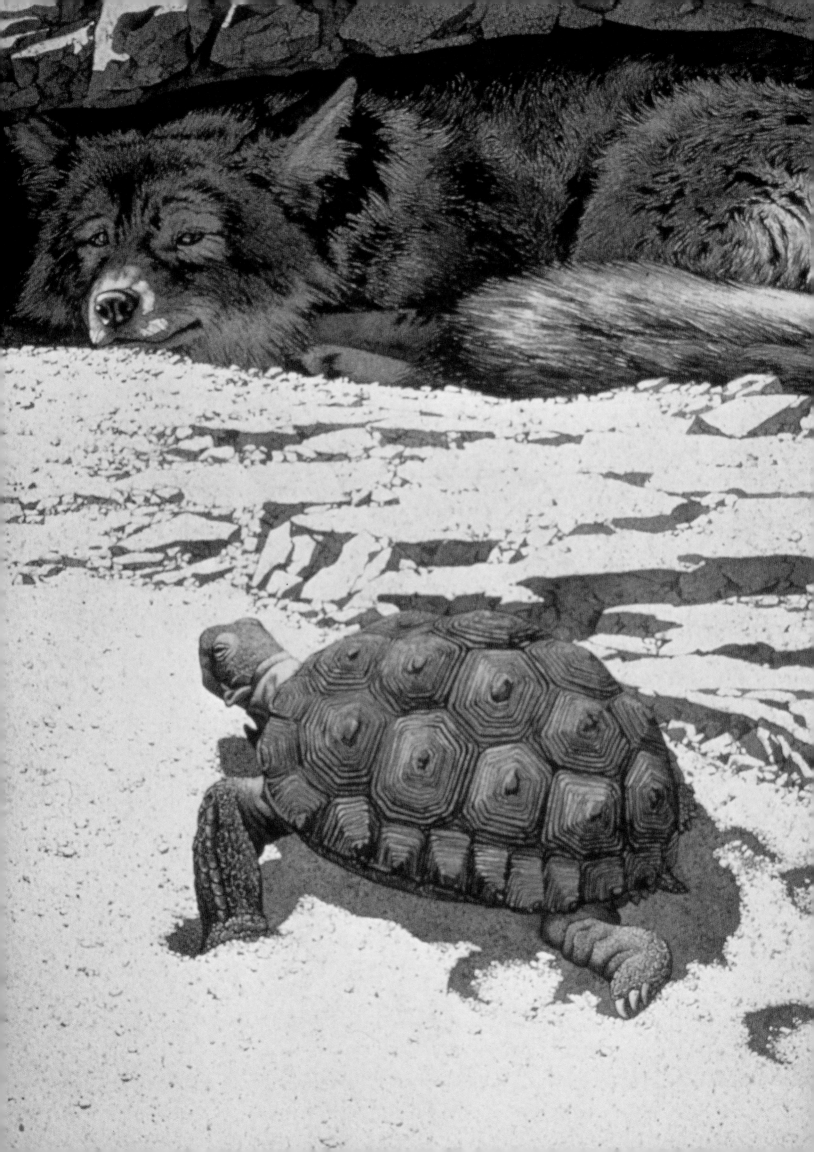

Coyote

When the world was young, the people were hungry even though great herds of buffalo roamed the plains and the people were good hunters with strong bows and sharp arrows. The buffalo had such keen eyesight that the hunters could not get near them. Coyote felt sorry for the people, so he kicked sand in the buffalo's eyes. From that day on, the buffalo was not able to see clearly, so the hunters were able to get close enough to hunt them, and the people were not hungry anymore.

This is a legend told by the Sioux, but many other tribes told coyote stories. In some of these stories, Coyote is the hero; in others he is a mischief maker. But he is always clever. The Indians of the Pacific Northwest say it was Coyote who filled the rivers with salmon. Later, he became angry at an Indian chief who refused to let Coyote marry his beautiful daughter. To punish the Indian chief, Coyote blocked the salmon from going up the Spokane River in Washington State to spawn, by making the spectacular Spokane Falls.

The Indians were right about the coyote's cleverness. An animal has to be smart to survive, and coyotes have been evolving and adapting for two million years. In spite of human efforts to eradicate them, coyotes not only survive but are sighted in more and more places—sometimes even in city parks or backyards.

There are nineteen subspecies of coyotes. All belong to the dog family (Canidae) and resemble dogs in many ways. A coyote's legs are longer and thinner than a dog's, and its feet are smaller. Unlike big cats, coyotes cannot retract their claws so a coyote's track usually includes claws as well as toes—four toes on the hind feet, five on the front. Coyotes usually travel in a straight line, and when they want to, they can really go fast—thirteen miles an hour walking, and thirty miles an hour if they gallop. They have a keen sense of smell, acute hearing, and sharp eyesight.

The most remarkable thing about the coyote is its voice. Coyotes can bark, yip, growl, wail, yell, howl, and even, according to biologists, sing bass, soprano, or tenor. A coyote concert usually begins at dusk and may continue long after moonrise. A few coyotes together sound like a huge chorus. The sound carries a great distance and is sometimes answered by other coyotes far away. Researchers say coyotes recognize each other's voices and may howl to warn other coyotes, to say they have found food, or to ask for help. As the Indians were quick to recognize, coyotes have many characteristics we think of as human. Sometimes coyotes howl simply because it's whooping fun!

Wolf

The legendary founders of the city of Rome, Romulus and Remus, were twin, motherless boys who were suckled by a female wolf. In the story of Little Red Riding Hood, a wolf eats Grandma, hops into her bed, and wears her lace cap in order to trick the granddaughter. Some Native American tribes called the wolf "Grandfather" to show their great respect for this animal. Almost every tribe admired the wolf for its loyalty to the pack, its stamina, and its ability to track.

For hundreds of years, people have been telling stories about wolves. Every hunter, trapper, Native American tribe, naturalist, and park ranger seems to have a wolf story. More recently, scientists have begun to study wolves. Observing wolves in their native habitat isn't easy. Even

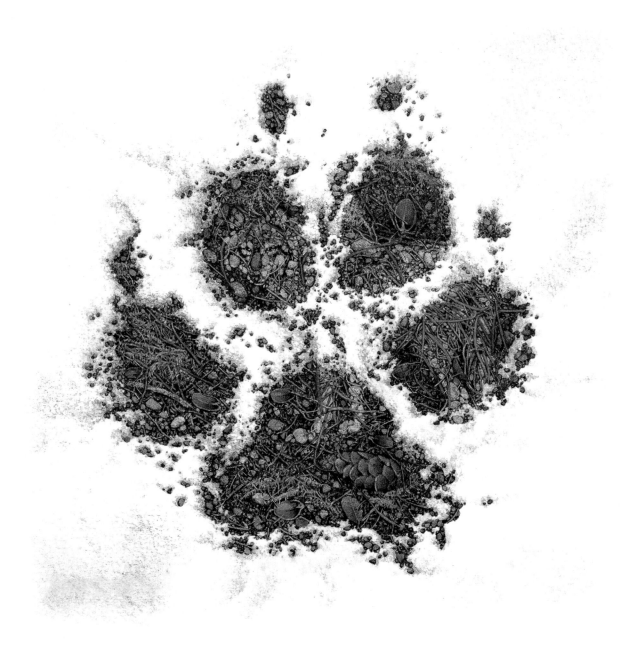

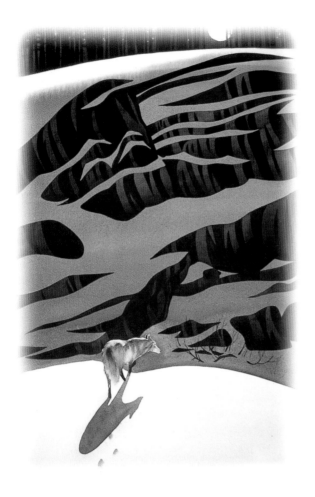

with our modern technology, wolves elude us. Shy, stealthy, and swift, they range hundreds of miles. In the last century, as farm and ranch land continue to expand, the wolf's habitat began to overlap man's habitat, and since wolves hunt other animals, they occasionally "hunt" a farmer's barnyard animals or a rancher's cattle.

Man would hunt and kill wolves, sometimes for revenge and sometimes for status. By the late twentieth century, wolves had almost been hunted out of existence. Now people are beginning to rethink the situation. When the wolf population goes down, the deer population goes up, and the balance of nature is altered. For environmental activists, the endangered wolf symbolizes the loss of wilderness land in the United States. Today there is a movement to return the wolf to Yellowstone National Park in the West and to Adirondack Park in northern New England.

As scientific research teaches us more about wolves, Indian legends and old wives' tales seem to contain some truth. Researchers have discovered that wolves can be generous and kind within the pack. Old or wounded wolves are allowed to eat what the other wolves kill. Adults sometimes bring meat to pups that are not their own. The highest-ranking male or female wolf is called the *alpha*. Alpha wolves tend to be large, strong, confident, and aggressive. Low-ranking wolves tend to be nervous and shy. Usually the alpha runs at the head of the pack, but the organization of the pack is not simple. No single wolf decides when the pack must move or where it must go. And although one wolf starts pack howling, it is not always the alpha.

One thing is sure: if you howl into the wilderness and a wolf howls back, it is a sound you will never forget. It *is* the sound of wilderness.

Fox

What do foxes, wolves, coyotes, and jackals have in common? They are all part of the dog family. Foxes are the smallest members of the dog family and, like dogs, they are omnivores, eating both meat and fruit but preferring meat. Foxes like to hunt near human farmland because the animal feed and open meadows attract the mice that they love to eat. They also eat rabbits, voles, large insects, and berries. Unlike domestic dogs, a fox not only smells and hears extraordinarily well, he also has excellent vision. A fox's den, where the young are born, is underground. It is similar to a groundhog's hole. In fact, sometimes a fox will take over a groundhog's hole and expand it to fit its growing family.

The red fox is by far the most common species. It is found throughout the world. Other species of fox are the gray fox (that can climb trees), the "swift" or "kit" fox (that is smaller and most active at night), and the arctic fox (whose coat turns from white in the winter to brown in the summer). The swift fox is endangered in the United States and Canada. Human poisoning, trapping, and habitat destruction are the most likely causes of its disappearance.

Foxes have a reputation for intelligence and stealth. You may see *signs* of a fox, but not the fox itself. If you do manage to catch a glimpse of one of these swift, clever, and dainty creatures, you have a right to feel thrilled. You have just outfoxed the world's greatest escape artist.

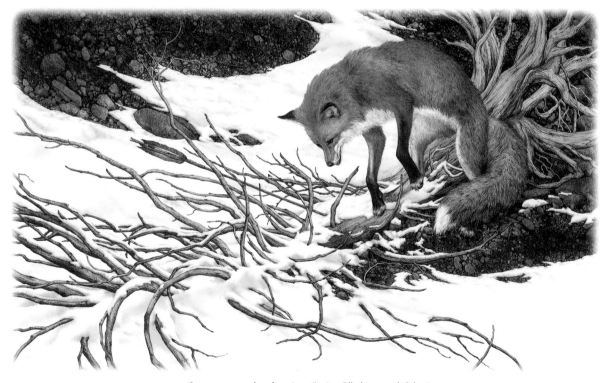

Can you see what has just "missed" this careful fox?

Trees

The boy was holding a book but his eyes were shut. He was trying to memorize what he had just read. The boy's teacher entered the room.

"Have you invented a way to read books with your eyes shut? " Ke-tha-cho-lee asked, laughing. The boy laughed, too. Ke-tha-cho-lee was his favorite teacher.

Ke-tha-cho-lee, whose Muskogee Creek name means Old Seer, was teaching the boy to see and understand the world around him and the world inside the boy's own mind and heart. Ke-tha-cho-lee did not use textbooks and he almost never answered questions.

"Come" he said, and the boy and the teacher (who was very old and very wise) walked a long way and slowly climbed a small hill covered with trees.

"Wrap your arms around this tree," Ke-tha-cho-lee said. The boy did. "Now wrap your legs around the tree." The boy did. "Sit there like that until I come back," the teacher said. Then he walked slowly back down the hill.

The boy wanted to call after him, "Why? When will you come back?" But he had learned to respect the wisdom of the elders, and he knew that Ke-tha-cho-lee loved him and was teaching him something important. So the boy asked himself: "What am I supposed to learn from this experience?"

At first all he could think of was how foolish he would feel if his friends saw him like this, wrapped around a tree. Then he worried about getting a cramp in his arms and legs. Most of all he was afraid of being alone. There was nothing to do, no one to talk to.

As time passed, the boy began to think about the tree. He looked up at its branches, felt its bark, wondered how old it was and how many storms it had seen. He forgot about his pride, his aches and pains, and he no longer felt alone. He felt connected to the tree, connected to the Creator. He felt at home.

That boy grew up to be the respected Muskogee Creek teacher and healer Marcellus Bear Heart Williams. He continues to spend his life demonstrating how ancient tribal wisdom can help people live better lives today. Today there may be cities where forests used to be, but we are children of the Earth with relatives in the wild. If we can reconnect with them, the four-footed ones, the ones that crawl and swim and fly, if we can respect their ways and live in harmony with plants and trees, mountains and seas, deserts and open sky, the wilderness will welcome us home.

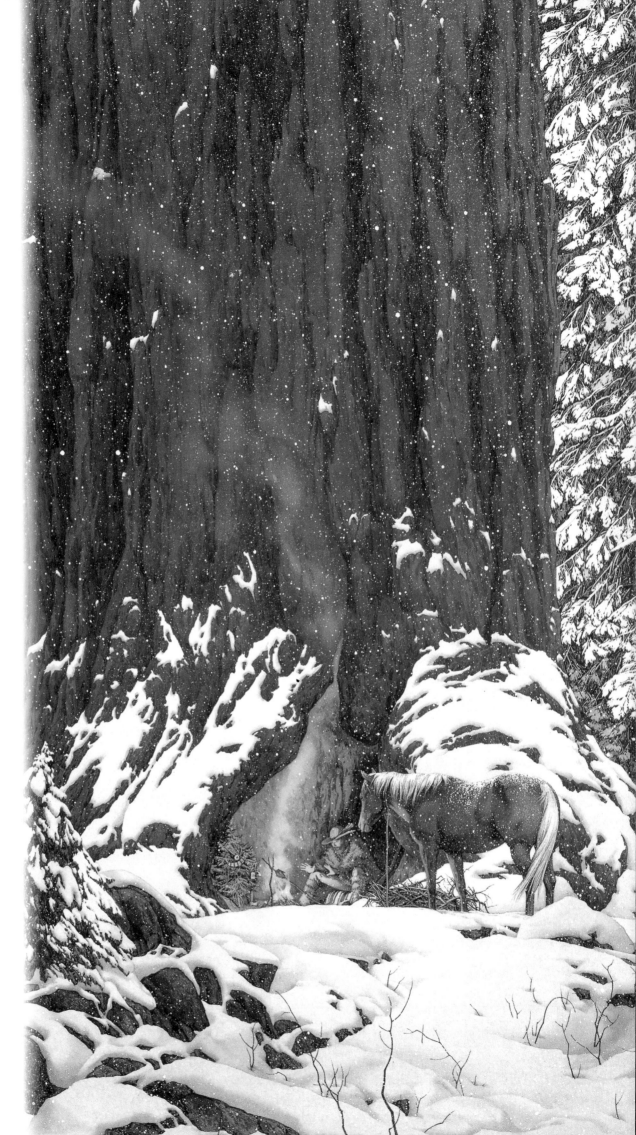

Like other animals in the forest, this mountain man is grateful for the shelter of an ancient redwood tree on a snowy winter night.